D1637677

Untitled, 2010
EC-135c aircraft engines, Effexor,
Citalopram and Mannitol
Length: 487.7cm
© the artist.
Gift of the artist and Corvi Mora, London.
Supported by The Henry Moore Foundation.

ACC25/2010

Roger Hiorns

UNTITLED

ACC25/2010

SOUTHBANK CENTRE **HAYWARD PUBLISHING**

LOTTERY FUNDED | Supported using public funding by **ARTS COUNCIL ENGLAND**

Looking Glass (or Operation Looking Glass) is the code name for an airborne command centre operated by the United States. It provides command and control of U.S. nuclear forces in the event that ground-based command centres are destroyed or otherwise rendered inoperable.

Looking Glass was initiated by the U.S. Air Force's Strategic Air Command in 1961 and operated by the 34th Air Refueling Squadron, Offutt AFB, Nebraska. In August 1966 the mission transferred to the 38th Strategic Reconnaissance Squadron, the 2nd Airborne Command and Control Squadron in April 1970, to the 7th Airborne Command and Control Squadron in July 1994, and to the U.S. Navy in October 1998.[1]

If it is our desire that art should reflect, interpret or divine the age that produces it, then *Untitled* (2010) fulfils this wish by conjuring with materials — engineering and pharmaceuticals — that are emblematic of the late twentieth and early twenty-first centuries. Though a primal fear of technology has long historical roots, reaching back to a pre-technologised era — H.G. Wells' *The War of the Worlds* was first published in 1898 — each

generation re-frames its anxiety in relation to the prevailing politics of the day. Published in 1953, at the start of the Cold War and only a few short years before the launch of Operation Looking Glass in 1961, Ray Bradbury's novel *Fahrenheit 451* imagines a world in which a wholly disengaged, self-sedating population mindlessly watches TV as 'final war' is prepared. The protagonist is described standing over the unconscious body of his wife, who has just OD'd on sleeping pills:

> As he stood there the sky over the house screamed. There was a tremendous ripping sound as if two giant hands had torn ten thousand miles of black linen down the seam. Montag was cut in half. He felt his chest chopped down and split apart. The jet bombs going over, going over, going over, one two, one two, one two, six of them, nine of them, twelve of them, one and one and one and another and another and another, did all the screaming for him. He opened his mouth and let their shriek come down and out between his bared teeth. The house shook. The flare went out in his hand. The moonstones vanished, he felt his hand plunge towards the telephone.[2]

Since 9/11, the spectre of death coming from the sky has taken on a new, more complex set of connotations, in that civil aviation has become implicated in acts of warfare: *Untitled* (2010) is, in a sense, the imagined other to Hiorns' work *Untitled* (2008), the materials for which are the pulverised components of a passenger aircraft engine, disposed across the gallery floor as a grey field of powder. In the later work the viewer is confronted with the physical presence of the pair of military engines, their fuselage partially pared back to reveal aeronautical engineering far beyond the comprehension of the non-specialist. Their power as objects is undeniable, and they are far from mute. Our imaginations are furnished with thousands of hours of archived images — 24-hour news cycle footage from conflicts across the globe — from which to furnish these objects with a biography.

Viewed purely as technology, however, the jet engines that comprise *Untitled* (2010) have not suffered apocalyptic atomisation, but stand before us intact, in a state of truce. The work presents to us a technology seldom examined, and strips away

part of its carapace in order to better expose its
essence. *Untitled* (2010) proposes that we consider
the elegant curve of the engine casings, the
pleasing symmetry of the turbine blades and the
complexity of the internal mechanisms, in order
that we contemplate what this reveals about the
minds that brought the engines in to being to act
upon the world. As human beings, we have created
objects the actions of which, at one and the same
time, comfort and appal us. As art, this technology
reveals the human. As technology, the engines
are transient, near obsolete and already slipping
inexorably into the past.

We are indebted to Tom Morton for a text that
brilliantly explores the many allusions arising
from *Untitled* (2010), and which situates it within
the broader context of Roger Hiorns' work to date,
illuminating the conceptual and philosophical
concerns that can be traced throughout his *oeuvre*
as well as the formal strategies he employs.
James Rondeau originally commissioned *Untitled*
(2010) for the Bluhm Family Terrace at the Art
Institute of Chicago and I should like to record
here our heartfelt thanks to Roger Hiorns and

Tommaso Corvi-Mora for the generosity of this gift to the Arts Council Collection. I also take this opportunity to record our gratitude to the Henry Moore Foundation and the Ministry of Defence for their prompt and extremely effective assistance in bringing this work of art across the Atlantic. Lastly, I extend our thanks to Studio April, who have done so much to help us conceive the first of this new series of publications, *ACC Works*, which will focus in-depth on important single works in the Arts Council Collection.

Caroline Douglas
Head of the Arts Council Collection

1 From *Wikipedia*, the free encyclopaedia.
2 Ray Bradbury, *Fahrenheit 451*, Harper Voyager, London, 2008, p. 22 (first published 1953).

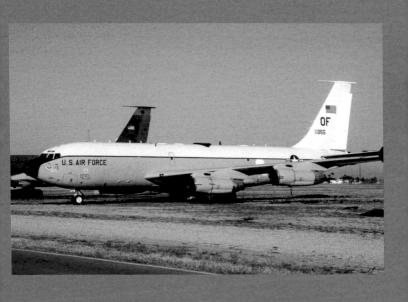

Boeing EC-135J, as used in Operation
Looking Glass, at Davis-Montham Air
Force Base, Tucson, Arizona.

Tom Morton on
Roger Hiorns' *Untitled* (2010)

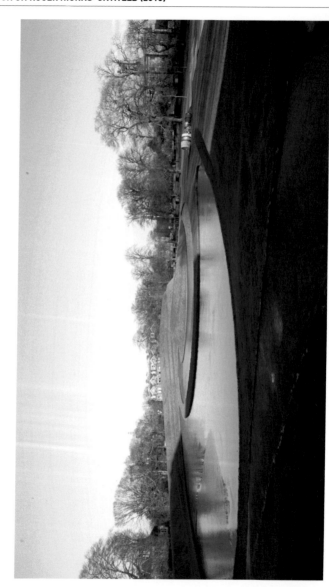

I placed a jar in Tennessee,
And round it was, upon a hill.
It made the slovenly wilderness
Surround that hill.

The wilderness rose up to it,
And sprawled around, no longer wild.
The jar was round upon the ground
And tall and of a port in air.

It took dominion everywhere.
The jar was gray and bare.
It did not give of bird or bush,
Like nothing else in Tennessee.

Wallace Stevens, *Anecdote of the Jar* (1919)

We should begin with what is there. The twin engines of a decommissioned military surveillance plane have been introduced into a landscape. Positioned in parallel, and in close proximity to each other, they do not immediately suggest an absent fuselage, or wings, only their own specific forms. Inside their hidden workings is a powdered measure of antidepressants – a psychoactive compound in place of combusting hydrocarbons, a drift of pharmaceutics in place of fossil fuel. Although the engines are large, solid objects, they are also permeable. There are points of ingress, and egress. There are grills and vents.

This is Roger Hiorns' *Untitled* (2010), a work that was first shown on the roof terrace of the Art Institute of Chicago in the spring of 2010, and was then installed (following its acquisition by the Arts Council Collection) on the grassy whorls of the architect and theorist Charles Jencks' landscaping project *Landform Ueda* (1999-2002) outside the Scottish National Gallery of Modern Art, Edinburgh, in February 2012. Manufactured by the American aerospace company Pratt & Whitney, *Untitled*'s engines once powered a Boeing EC-135c aircraft used in an ongoing US military initiative codenamed Operation Looking Glass, in which a fleet of perpetually airborne planes gathers intelligence for covert and conventional missions, while also serving as flying command and control centres for the nation's nuclear arsenal. These are objects, then,

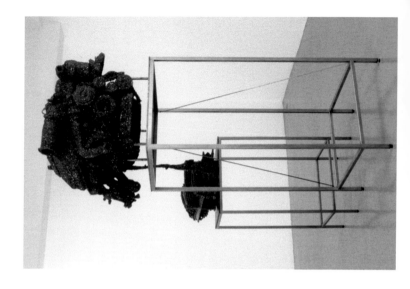

The birth of the
architect, 2003
8-series BMW engine,
steel, card and
copper sulphate,
235.5 × 139.5 × 77.5 cm

that have passed over borders, have been welcome or unwelcome, have refueled in mid-air above Iraq, or Iran, or Afghanistan, never once touching the troubled ground below. Operation Looking Glass's primary function is to preserve a particular way of life, often at the expense of others. Its secondary function is apocalyptic retribution, the heaping of death upon death. In a 'strike first' scenario, the order to empty America's atomic missile silos would issue from the White House, or the Pentagon, or the fastness of the Raven Rock Mountain Complex in Pennsylvania. It would only issue from an aircraft if these buildings, along with much of the continent, had already been reduced to a radioactive smear. While Hiorn's engines have been separated from their electronic eyes and ears, their ability to blind and to silence, they still provoke disquiet. Hugging the ground, they cast the limited shadows of all grounded things. Were they to rise, their shadows would grow, and spread, and finally disappear, leaving no trace of their presence above the fragile, turning Earth.

Untitled brings together two different tools that shape two different landscapes. While Looking Glass planes are designed to work on the exterior world, making it safer (or at least more profitable) for American interests, antidepressants are designed to smooth the fitful topography of the late-capitalist mind – we might note that in 2011, the US National Center for Health Statistics reported

that one in ten US citizens now regularly takes this medication, a 400 per cent increase since the fall of the Berlin Wall. Given the engines' anthropomorphism (they are, like us, complex sets of pipes and chambers, supported by an armature and protected by a 'skin') we might read them as anxious bodies, or heads, which the artist has attempted to pacify with a therapeutic draft. On a symbolic level, this is a very different procedure from, say, a Vietnam War protestor placing a flower in the barrel of a National Guardsman's gun.

In Untitled, violence is not overwhelmed by peace, but is rather subject to chemical management, and that is not without its forfeitures, or its risks – common side-effects of antidepressants include a loss of libido and a stalling of the creative drive, and, in rarer cases, an increased likelihood of psychosis and suicide. Do the drugged engines, then, experience a temporary, topical, and wholly synthetic, sense of calm? Unmoved by sex, or art, do they become dependent on their medication (this stuff is often addictive), even as it pushes them towards madness, or self-harm? Only in the human imagination, a realm where objects become imbued with human attributes, as though in testament to our species' solipsism, or its loneliness. To follow such thoughts too far, to fall into the deep trap of the pathetic fallacy, is to forget the obvious, vital fact that Untitled's engines are not made of living matter, and cannot metabolise the powdered

All Night Chemist, 2004
Engine, chair and copper
sulphate, 126 × 73 × 72 cm

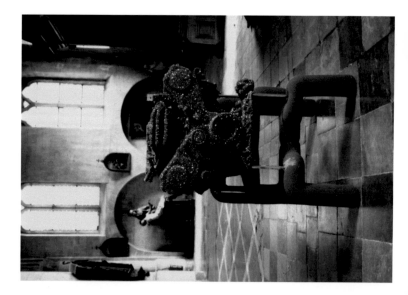

pills that dust their metal guts. What this work has occasioned is not a bonding of molecules, but an enforced obsolescence. By diverting these two technologies of control from their customary uses [we should note that the engines of decommissioned Looking Glass planes are regularly sold on to the Israeli military] Hiorns has rendered them inert, and it is in this inertia, in the sterile coupling of still turbines and stalling pharmaceuticals, that Untitled's strange poetry might be felt.

Hiorns has described the figure of the engine as a 'pure expression of power'. Lifted from the chassis of spent automobiles, these objects appear often in his oeuvre, crusted with copper sulphate crystals in early sculptures such as The birth of the architect (2003) and All Night Chemist (2004). First shown at the 2008 Busan Biennale, South Korea, this latter work suggests not a mystical union of animal and machine, nor a sci-fi cyborg fantasy, but rather the relationship between industrial processes and the erosion of subjectivity, and the problems and possibilities this entails. Recent medical research has linked cases of mental impairment in American abattoir workers to their sustained exposure to bovine brain tissue, and in Untitled (2008) this material might be said to represent a diminished self, or (if we understand the engine as an inorganic skull, or head, or body) one

that is incompatible with the instrument of its expression, or of its survival. Commenting on this work, Hiorns has written that 'the loss of the mind [involves] "recourse to intuition, the artist's staple tool"', and brings us close to 'infant experience' and a 'zero level of trauma'. Is Untitled (2008), then, merely an invocation of the everyday violence of capital, or does it also suggest a peculiar path to freedom, even a new way of being? Perhaps, in the end, it is about the impossibility of apprehending the facts of a non-human or post-human consciousness – as Hiorns has puts it, this work speaks of a 'stoppage', an irruption in what and how we know.

If Untitled (2008) contains an alien mind, then Untitled (Paul) (2009-2011) provides a vessel for something far closer to home. For this work, first shown at the Hayward Gallery, London, as part of British Art Show 7: In the Days of the Comet, Hiorns made a donation to a South London church, in exchange for the congregants promising to remember 'Paul' in their prayers. 'Paul', however, is not a person, but the name the artist gave to a Mercedes engine, and what is in play here is a complex game of intention, language and belief. Looking at Untitled (Paul), which bears no visible signs of divine intercession, a man of faith might argue that the congregants did not honour their commitment, or that supplication only works when the imagined beneficiary has a genuine human match,

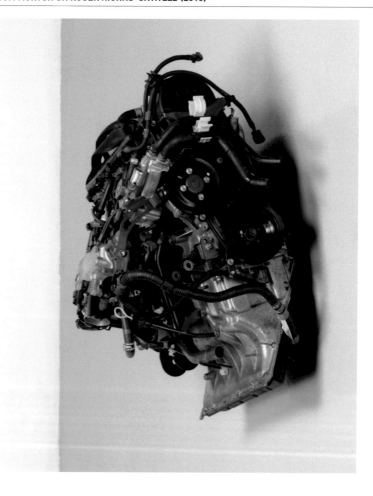

Untitled, 2008
Toyota engine,
brain matter,
48 x 69 x 59cm

or else that the problem is one of perception, and that anybody would recognise that the engine had, in fact, been blessed, if they had but eyes to see. For the faithless, this work is a somewhat simpler proposition – in the absence of a God, a prayer is merely a misplaced hope. Untitled (Paul), however, still confronts even the most devout skeptic with an object that exceeds its own simple object-hood. Hiorns' act of linguistic designation [and, more complicatedly, its communal acceptance] has given this engine another, invisible dimension. Belief, or maybe will, has transformed it into a work of art.[1]

Originally exhibited at Corvi-Mora, London, Hiorns' Untitled (2008, p. 22) comprises the atomised remains of the engine of a passenger aircraft. Scattered across the gallery space, the grey particles form a lunar landscape, a series of mineral hills and valleys utterly inhospitable to life. On one level, this is a work concerned with universal entropy, the hopelessness of human effort in the face of time's infinite stretch. On another, it addresses a particular object, the commercial jet engine, which is implicated in irreversible climate change and our species' ongoing act of collective suicide. Significantly, the work's formal and conceptual integrity depends upon it being exhibited in a gallery or museum. The institution, here, performs an almost placental or womb-like role, nourishing and protecting an image of collapse that, in turn, allows the institution to fulfill its

purpose. Untitled (2008) asks us to contemplate the sure fact that, in the very long term, both the powdered metal and its architectural casings will be reduced to their component atoms. Contrast, and meaning, belong only to a limited temporal period. If the engine is a 'pure expression of power', it remains, like every human artifact, impotent in the face of the future, the endless patient days that file forward to undo.

In the American poet Wallace Stevens' poem The Anecdote of the Jar (1919), the narrator places a simple glass container on a Tennessee hilltop, an action that appears to discipline the surrounding landscape. Taking 'dominion everywhere', this 'gray and bare' object gathers the 'wilderness' towards itself, until it is 'no longer wild'. We might read this work as an allegory of industrialisation, or else as a fretful attempt to shrug off the imported language of European poetry, and find a new voice with which to speak of the New World [Stevens flits back and forth between stately, if awkward, expressions such as 'of a port in air', and passages such as 'the jar was round upon the ground', in which a bracing plainness of speech threatens to tip over into doggerel]. At the poem's heart, however, is the absurdity of human attempts to frame an unframeable universe: the jar may temporarily arrange 'slovenly' nature into something like a still life, but it is ultimately a barren object, unable to 'give of bird or bush'.

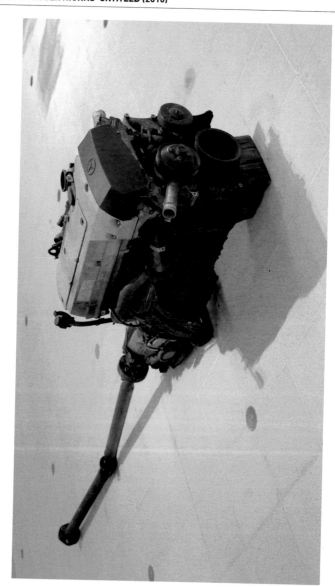

Untitled (Paul), 2009-2011
Mercedes Benz car engine,
prayer group, 300 × 95 × 95 cm

To date, *Untitled* (2010) has not been set down in an untouched spot, but in highly artificial environments: the solemn Modernist spires of the Chicago skyline, and the playful Postmodernist pastoralia of Jencks' *Landform*.² If it has worked on these surroundings, then these surroundings have also worked on it. Operation Looking Glass commenced in 1961, and its fleet has flown in what we have called the Modern period, and the Postmodern period, and remains airborne to this day – looking, listening, always ready to sound America's final, senselessly aggressive death-rattle. To ground *Untitled*'s engines in a specific, historically marked landscape is to return them to the human sphere, where we might contemplate their radical antipathy to human concerns. Hiorns has said that Operation Looking Glass will come to be regarded as 'reprehensible in the future'. If so, this will be because, like all apparatuses of catastrophe, its final purpose is to do away with history, which needs us, and to replace it with time, which does not.

Hiorns' engines all pivot on dysfunction, or its spectre. Turned from their intended use, they fail and fail again: as brainpans, as vessels for divine grace, and even, in the case of the atomised turbine, as coherent sculptural forms. Most of all, they fail as metaphors – not because they suffer from some poetic illogic, or deficit, but because they assert that they are only, and finally, themselves. Hiorns is often described as an 'alchemist', but this seems to me to be the precise opposite of the truth. He does not transmute one thing into another, or only objects into art, and even then he does so in the knowledge that this is a kind of cultural reflex, or a ritual observance carried out according to conventions that long predate his birth. It is we viewers (with our wants, and our traumas) who urge Hiorns' objects to become more than they are, and in this we indulge a broader human habit. Like Stevens' narrator placing his jar on the lonely Tennessee hilltop, we imagine that we might draw the exterior world towards us, while all around it falls away, untroubled and uncaring – indifferent to the small, precious self that has transformed it into a view.³

Notes
1. A note on what might have been. Before Hiorns settled on introducing a handful of crushed antidepressants into *Untitled* (2010), he considered making the work's twin engines the beneficiaries of supplication, using much the same method he employed in *Untitled (Paul)* (2009-2011). Given that Hiorn's congregants are instructed only to pray for 'X' or 'Y', we might wonder what effect their prayers would have had in this case. The short answer is none whatsoever. The longer answer, at least for those habituated to magical thinking, might be that the grounded turbines would move closer to God. Considering the history of Operation Looking Glass, to imagine these engines ascending to heaven is to experience not a vision of Grace, but of the eschatological sublime. Another possible iteration of *Untitled* (2010) proposed by the artist at the time of the Chicago installation

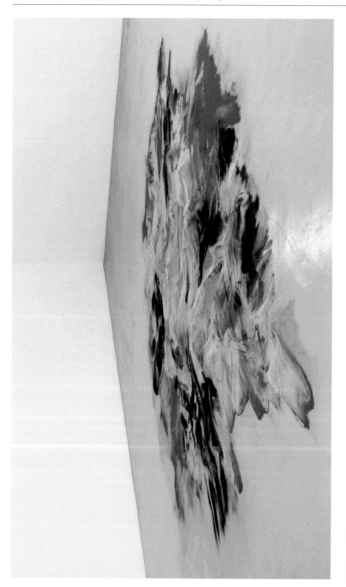

Untitled, 2008
Atomised passenger
aircraft engine,
dimensions variable

would have seen the engines become subject to the ministry of a mechanic, who would have ensured that they were maintained to performance level at all times. Hiorns has said that 'the inability to supply this presence led to antidepressants being prescribed'. *Untitled* (2010) may, in future, become the locus of further actions, as yet unannounced by the artist. As new necessities emerge, so will new modes of maintenance – beyond the metaphysical, the mechanical, or the pharmacological.

2.
A second note on what might have been. Among the buildings visible from the roof terrace of the Art Institute of Chicago is the Modernist skyscraper of the former Standard Oil Building, now the Aon Centre, which was completed in 1974, some two years after the demolition of the Pruitt-Igoe social housing project in St Louis, Missouri – an event that Charles Jencks identified as the final death-rattle of Modernism. Designed by Edward Durell Stone and the Perkins and Wills partnership, the Aon Centre is clad in Carrara marble – a material associated with the antique past and its numerous revivals, not least the Fascist strand of Neo-Classically-informed Modernism encouraged by Benito Mussolini in 1930s Italy. In his preparatory notes for the Chicago install, Hiorns considers the possibility of lighting *Untitled* (2010) with a searchlight positioned on the Aon Centre's rooftop, the bulb of which would be coated with his semen. Three years earlier, in 2007, the artist introduced this material to one of the lamps that illuminate the Parthenon, as part of the exhibition *How to Endure* at the 1st Athens Biennale. In each case, we might understand Hiorns' action as a willfully futile attempt to claim the past [and

its authority), or else to imprint a single human self on the edifice of power. Filtered through his body fluids, the lamplight undergoes an infinitesimal change, as does the rate at which it bleaches these vast buildings' pale facades.

3.
A third note on what might have been. Hiorns has suggested that *Untitled* (2010) may be approached through his own reworking of another poem by Wallace Stevens, *Angel Surrounded by Paysans* (1949), in which the word 'earth' would be replaced by 'sun'.

One of the countrymen:
 There is
A welcome at the door to which no one comes?
The angel:

I am the angel of reality,
Seen for a moment standing in the door.
I have neither ashen wing nor wear of one
And live without a tepid aureole.
Or stars that follow me, not to attend.
But, of my being and its knowing, part.
I am one of you and being one of you
Is being and knowing what I am and know.
Yet I am the necessary angel of earth,
Since, in my sight, you see the earth again,
Cleared of its stiff and stubborn, man-locked set,
And, in my hearing, you hear its tragic drone
Rise liquidly in liquid lingerings
Like watery words awash; like meanings said
By repetitions of half meanings. Am I not,
Myself, only half of a figure of a sort,
A figure half seen, or seen for a moment, a man
Of the mind, an apparition apparelled in
Apparels of such lightest look that a turn
Of my shoulder and quickly, too quickly, I am gone?

B-52/EC/KC/RC-135 ENGINE TRIM AND EXHAUST GAS TEMPERATURE SPREAD CHECK
(To be filed and maintained with engine historical records)

DATE OF TRIM	TYPE AIRCRAFT- SERIAL NO.	ORGANIZATION	STATION
SEP. 16, 1987	EC-135J /1AB055	15 CAMS	HAFB

MDS ENGINE	ENGINE SERIAL NUMBER	ENGINE OPERATING TIME	FUEL CONTROL SERIAL NO.
TF33-P9	P643502	2518	39061

DATA PLATE RPM	% RPM	TRIM CHART RPM CORRECTION	CORRECTED % RPM
8811	91.26%	+1.8	93.08%

BAROMETRIC PRESSURE	AMBIENT TEMPERATURE	REASON FOR TRIM	TRIM EQUIPMENT USED
30.0	80°	FUEL CONTROL CHG. BH112JB40	

AIRCRAFT HEADING	WEATHER CONDITIONS AND TIME OF TRIM (Rain, snow, (ain etc)
045	FAIR 0900

WIND DIRECTION /VELOCITY	FUEL CONTROL LINKAGE CHECK
045/ 8 KNOTS	SSGT HARDWICK

TYPE TRIM (Check applicable block) ENGINE PNEUMATIC DUCT LEAKAGE CHECK
☐ FULL POWER ☒ PART POWER A/C GRIGAS

TRIM CHART PT7/EPR TARGETS

DRY PT7 357 /TF33	40.1	DRY SET PT7 J57		DATA PLATE RPM TARGET PT7 VALUE		WET PT7 J57		TAKEOFF PT7 TF33 53.2
DRY EPR J57 /TF33	1.34	DRY SET EPR J57		TF33 40.2		WET EPR J57		TAKEOFF EPR TF33 1.77

% IDLE RPM	59.0%		IDLE EGT	335°		
BLEED VALVES	EPR R CLOSES	80.7%	EPR L CLOSES	R OPENS	EPR 78.2% L OPENS	EPR

J57 /TF33 DRY TRIM DATA PRIOR TO FUEL CONTROL ADJUSTMENT

	EPR	% RPM	EGT	FUEL FLOW	INDICATED OIL PRESSURE
COCKPIT	1.28	91.0	390°	4800	50
TRIM EQUIPMENT	PT7 38.20	% RPM 91.3	EGT 390°		DIRECT OIL PRESSURE

J57 /TF33 DRY TRIM DATA AFTER FUEL CONTROL ADJUSTMENT

	EPR	% RPM	EGT	FUEL FLOW	INDICATED OIL PRESSURE
COCKPIT	1.34	94.0	405	5000	50
TRIM EQUIPMENT	PT7 40.13	% RPM 93.8	EGT 404		DIRECT OIL PRESSURE

J57 WET TRIM DATA AFTER FUEL CONTROL ADJUSTMENT

	EPR	% RPM	EGT	FUEL FLOW	INDICATED OIL PRESSURE
COCKPIT					
TRIM EQUIPMENT	PT7	% RPM	EGT		DIRECT OIL PRESSURE

TF33 DATA DURING DATA PLATE RPM CHECK

	EPR	% RPM	EGT	FUEL FLOW	INDICATED OIL PRESSURE
COCKPIT	1.34	94.5	400	5000	50
TRIM EQUIPMENT	PT7 40.22	% RPM 94.6	EGT 403		DIRECT OIL PRESSURE

TF33 DATA DURING TAKE OFF THRUST CHECK

	EPR	% RPM	EGT	FUEL FLOW	INDICATED OIL PRESSURE
COCKPIT	1.77	102.4	540	10000	52
TRIM EQUIPMENT	PT7 53.23	% RPM 103.3	EGT 531		DIRECT OIL PRESSURE

DATA EVALUATION	% RPM OVER DATA PLACE RPM (Trim equipment RPM versus corrected data plate RPM)	EPR DIFFERENTIAL (Indicated cockpit EPR versus Trim Chart EPR)
	+1.52	— 0 —

JET CAL THERMOCOUPLE PROBE CHECK

EXHAUST GAS TEMPERATURE CHECK	PROBE NUMBER	1	2	3	4	5	6	7	8
	EXHAUST GAS TEMPERATURE °C	550°	555°	INOP	533°	542°	501°		
	AVERAGE EGT °C 536°		EGT °C 550-501.			MAXIMUM TEMPERATURE °C 19°			

REMARKS ① Anti ice drop ck. good.

A/C TIME 11660
SIGNATURE OF TRIM SPECIALIST

#3 pos thermocouple on JETCAL INOP.

SIGNATURE (Supervisor of Trim Specialist)
Brend A. Thomas WG-10

AFTO FORM 132 MAR 70 PREVIOUS EDITIONS ARE OBSOLETE AFLC-WPAFB-MAY 74 14M

RESEARCH

(Opposite and pp. 26–29) Selected pages from
the log books for jet engines used in *Untitled* (2010).
(pp. 30–31) Patient information leaflet and packaging
for Citalopram tablets, from *Untitled* (2010).
(pp. 32–37) Study photos by the artist, 2005–2012.

SIGNIFICANT HISTORICAL DAT.

1. MISSION DESIGN SERIES/TYPE, MODEL AND SERIES	2. MANUFACTURER
TF33P9	PRATT & WHITNEY

DATE A	REMARKS B
23Jul82	List of Previous Overhauls: NONE

Engine given Major O/H. Reason 2J-1-27.

Compressor Rotor No I P/N 487200 S.
 No II 457145
Turbine Rotor Stg No 1 693802
 Stg No 2 748222
 Stg No 3 675823
 Stg No 4 499934

Engine given Major O/H IAW 2J-TF33-3 , dtd 15

DIFFUSER CASE: P/N 586559 S/N

TOTAL TIME: 7729 TOTAL CYCLES:

TURBINE NOZZLE VANE AVERAGE CLASS:
1st 21.71
2nd 9.91
3rd 2.70
4th 6.70

27 JUL 1982 Preserved IAW 2J-1-18, Sect. 6.,
 Applicable Para C/W
 INSPECTOR

27 JUL 1982 ENGINE PRESERVED IAW
 TO 2J-1-18 SEC 3
 PARA. 18-19
 Engine shipped at 00 hrs. since O/H. TOTAL TIME:

AFTO FORM 95 PREVIOUS EDITION WILL BE USED.
FEB 65

3. SERIAL NUMBER	4. ACCEPTANCE DATE
P644622	27 Jul 64

PAGE OF PAGES

ORGANIZATION

OC/ALC

729
000

T/T	10322
	16523
	000
	14903
	4675
	2400

NE RECORDS SPECIALIST

OKLA CITY ALC

OC
41951

INSPECTOR

TAL CYCLES: 3417

OC/ALC SUPPLY DIV.

TURBINE WHEEL HISTORICAL RECORD

1. AF PART NUMBER	2. MANUFACTURER'S NUMBER		
499934	ROTOR ASSY S/N 7X3269		774

5.		6.			ABNORMA
WHEELBLANK DIAMETRICAL MEASUREMENT		DATE A.	ENGINE TIME B.	WHEEL TIME C.	TEMPERATUR OR SPEED D.
NEW					
1ST OVERHAUL	18.558				
2ND OVERHAUL					
3RD OVERHAUL					
4TH OVERHAUL					
5TH OVERHAUL					
6TH OVERHAUL					
7TH OVERHAUL					
8TH OVERHAUL					

7.				INSTALLATION DATA	
ACTIVITY A.	ENGINE MODEL AND SERIAL NO. B.	INSTALLED		REMO	
		DATE C.	ENG TIME D.	DATE E.	
~~Sacramento~~ Sacramento ALC	TF33P9 P644393	5APR84	10,070.0 T/Cyc: 1834		
SACRAMENTO ALC	TF33P9 P644393			9NOV88	
SACRAMENTO ALC	TF33P9 P644215	9NOV88	14213.8 T/CYC 6281		

AFTO FORM 44
FEB 81

PREVIOUS EDITION WILL B

| | | OMB NO. 21—R0104 |
| | | EXPIRES MARCH 1983 |

NUMBER	4. TURBINE STAGE NUMBER
3X2160	4

D/OR OVERSPEED DATA

		NATURE AND POSSIBLE CAUSE F.

WHEEL TIME INCE NEW G.	WHEEL TIME SINCE OVHL H.	REASON FOR REMOVAL I.
2702 T/Cyc: 338		
AME AS BOVE	2367.1 T/CYC 2,252	REMOVED AND REINSTALLED IN TF33P9 P644215
AME AS ABOVE	SAME AS ABOVE	

⚠ SANDOZ

PATIENT INFORMATION LEAFLET
Citalopram 10mg, 20mg and 40mg Tablets

SZ90404LT01B

What you should know about Citalopram Tablets

Please read this leaflet carefully before you start taking your medicine. This leaflet provides a summary of the information available on your medicine. Keep it so that you can read it again if you need to. If you have any questions or are not sure about anything ask your doctor or pharmacist.
The name of your medicine is Citalopram 10mg, 20mg or 40mg Tablets.

What is in your medicine?

Each film-coated tablet contains the equivalent of 10mg, 20mg or 40mg of the active ingredient citalopram (as hydrobromide). The tablet core contains mannitol (E421), microcrystalline cellulose (E460i), anhydrous colloidal silica and magnesium stearate (E572). The tablet coating contains hypromellose (E464), macrogol and titanium dioxide (E171).
Citalopram Tablets are available in packs of 28.
The active ingredient citalopram hydrobromide belongs to a group of medicines called selective serotonin re-uptake inhibitors (SSRIs) which are a type of antidepressant used to treat major episodes of depression.
The Marketing Authorisation Holder of this medicine is Sandoz Ltd, Woolmer Way, Bordon, Hants, GU35 9QE.
The manufacturer is Sandoz Pharmaceuticals GmbH, Carl-Zeiss-Ring 3, D 85737 Ismaning, Germany.

Uses

Citalopram Tablets are used to treat major episodes of depression.

Before taking your medicine

DO NOT take this medicine and talk to your doctor if you can answer yes to any of the following questions:
• are you allergic to citalopram hydrobromide or any other ingredients in this tablet?
• are you taking any medicines known as monoamine oxidase inhibitors (MAOIs) for example phenelzine or moclobemide (also known as a reversible MAOI or RIMA), also used to treat depression, or selegiline used to treat Parkinson's Disease?

If Citalopram Tablets are taken with a MAOI or if a MAOI is started very soon after stopping Citalopram Tablets serious reactions, which on occasions have proved fatal, may occur with symptoms such as agitation, tremor, stiffness, muscle spasm, rigidity, confusion, irritability, fever, delirium and coma.

If you have been taking a MAOI, you should not start taking Citalopram Tablets for two weeks after stopping the MAOI.

A MAOI should not be taken for at least seven days after stopping treatment with Citalopram Tablets.

• are you, could you be or are you planning to become pregnant?
• are you breast-feeding?
• are you taking any of the following medicines:
 ◦ sumatriptan or other similar medicines (such as oxitriptan) or ergotamine (to relieve the symptoms of migraine)?
 ◦ tramadol (for the treatment of pain)?
 ◦ tryptophan (sometimes used to treat depression)?
 ◦ herbal preparations containing St. John's Wort (*Hypericum perforatum*)?
 Citalopram Tablets and St. John's Wort should not be taken together as this may result in an increase in unwanted side-effects.
 None of the above medicines should be taken at the same time as citalopram.

DO NOT take this medicine before talking to your doctor if you can answer yes to any of the following questions:
• Have you ever thought about suicide or tried to take your own life?
• Do you have a history of mental illnesses, in particular schizophrenia?
• Do you suffer from mania (hallucinations, great excitement, difficulty concentrating, difficulty in staying still)?
• Are you diabetic?
 If you are, the treatment for your diabetes (insulin or tablets) may need to be adjusted.
• Do you have epilepsy?
 You may develop seizures/fits or these may occur more often when taking Citalopram Tablets. For this reason your doctor will carry out regular check-ups to ensure that your epilepsy remains well controlled. Citalopram Tablets should be stopped if you start having more fits than usual or if you have a fit for the first time. You should then see your doctor immediately.
• Do you have kidney or liver disease?
 If you have liver disease your doctor will need to monitor your liver function and may take blood tests.
• Do you have any problems with your heart or an abnormal heart rhythm?
• Do you have a history of bleeding disorders/abnormal bleeding?
• Are you taking any drugs to thin your blood such as warfarin? Are you taking any other medicines which can cause bleeding such as non-steroidal anti-inflammatory drugs (also known as NSAIDs) such as ibuprofen or diclofenac, aspirin, dipyridamol or ticlopidine or any medicines used to treat mental illness, such as chlorpromazine, clozapine, amisulpride, risperidone, or other medicines to treat depression, such as amitriptyline, clomipramine, doxepin?
 Taking any of these medicines at the same time as citalopram can increase the risk of bleeding.
• Are you currently under going electro-convulsive therapy (ECT)?

As there may not be any improvement in your symptoms during the first few weeks of treatment your doctor will need to monitor you closely. You may experience an increase in depressive symptoms, and even suicidal thoughts until the tablets begin to work. If this happens you should talk to your doctor straightaway.
If you are being treated for a psychotic illness (mental illness) with depressive episodes, you may find that the symptoms of your illness increase.
Insomnia (difficulty sleeping) and feelings of agitation can occur at the start of treatment and so your doctor may start your treatment at a low dose and then increase the dose slowly as necessary.

It is important to let your doctor know of all medicines you are taking before taking the Citalopram Tablets, particularly those mentioned previously in this Leaflet and metoprolol (as your doctor will monitor your blood pressure or heart rate); lithium (as your doctor will need to monitor your lithium levels); imipramine (as your doctor may need to adjust your dose of imipramine); cimetidine (as it may be necessary to check the blood levels of citalopram if you are on a high dose); or any other medication you may have obtained without a prescription.
If you need to see another doctor or go into hospital you should take all medicines, including Citalopram Tablets with you in order that the doctors will know exactly what you are taking.

You should NOT drive or operate machinery if you feel dizzy, drowsy or your co-ordination is impaired while taking Citalopram Tablets. The tablets may also affect your ability to make judgements and to react to emergencies. If you are affected in any way you should NOT drive or operate machinery.

Do NOT drink alcohol while taking Citalopram Tablets.

32 024 0 / T5000490

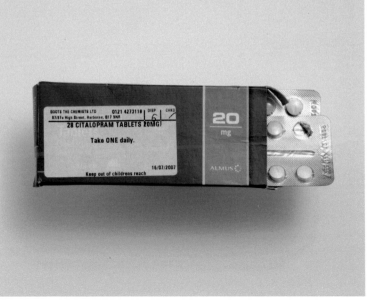

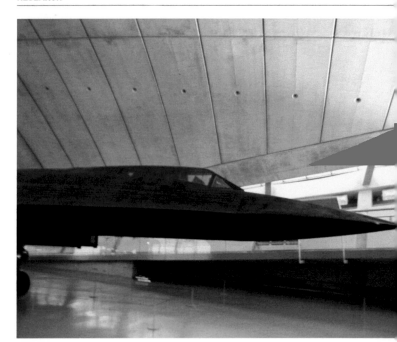

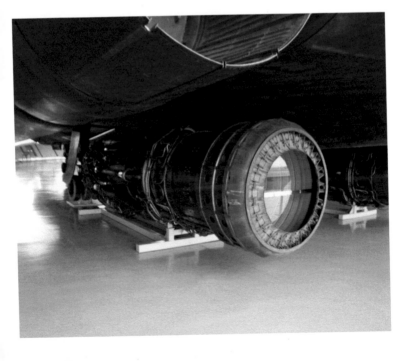

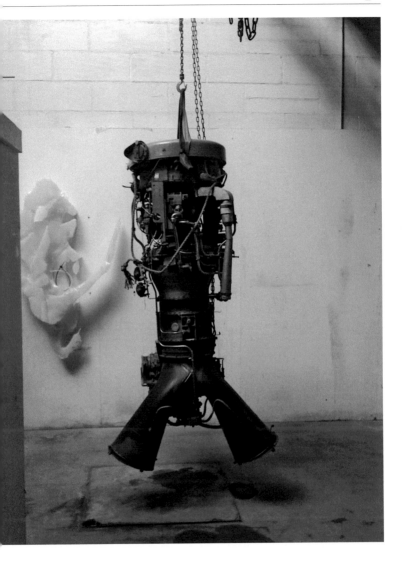

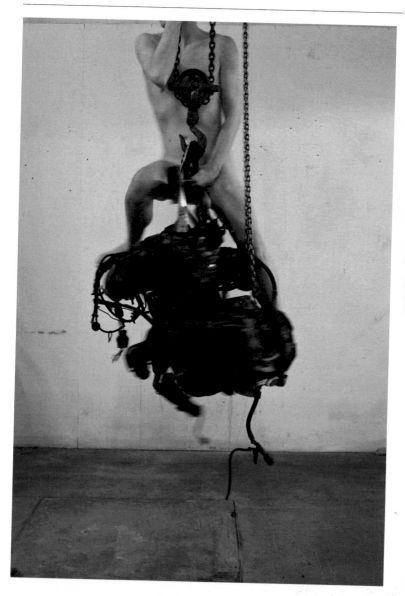

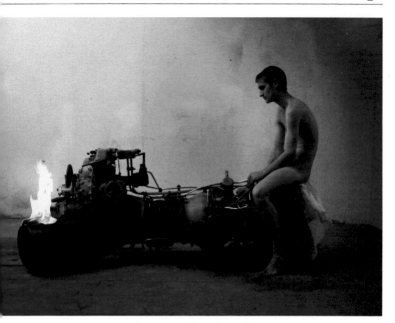

CHICAGO

Installation of Roger Hiorns' *Untitled* in the
Bluhm Family Terrace, Monday April 26, 2010,
The Art Institute of Chicago.

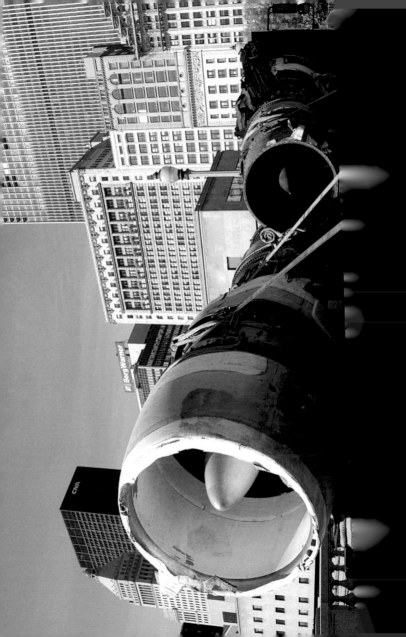

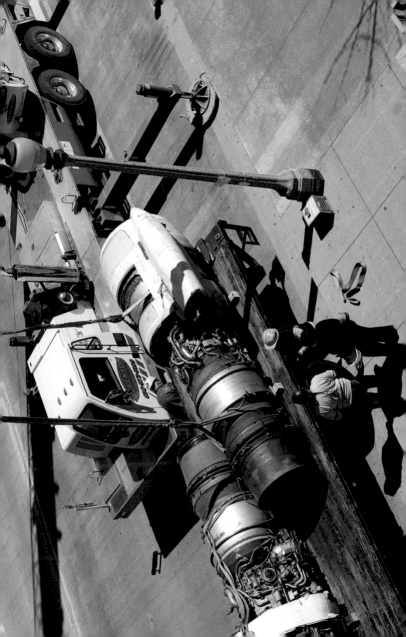

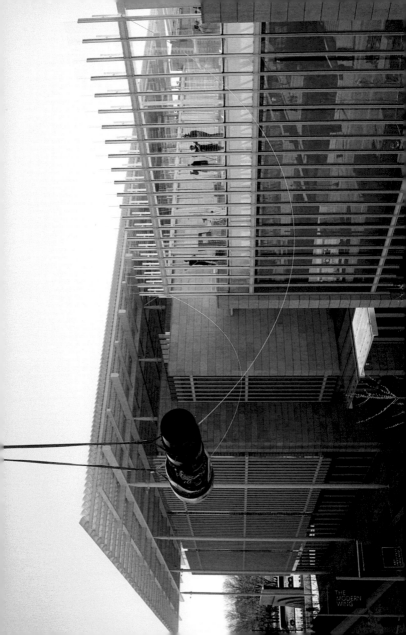

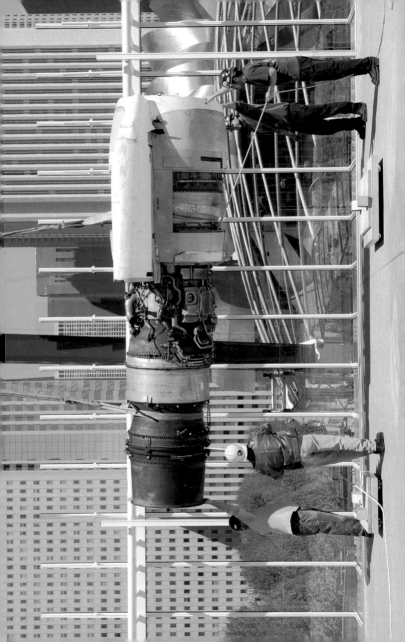

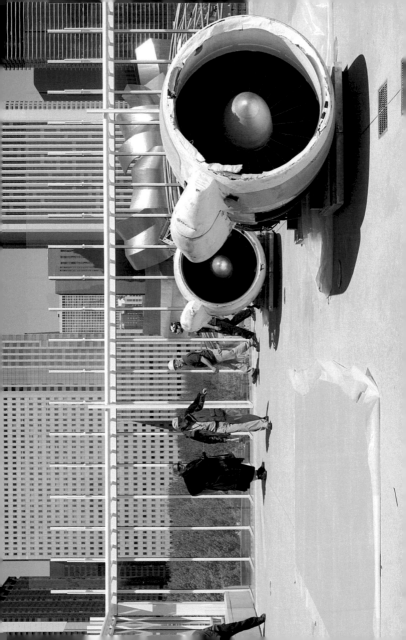

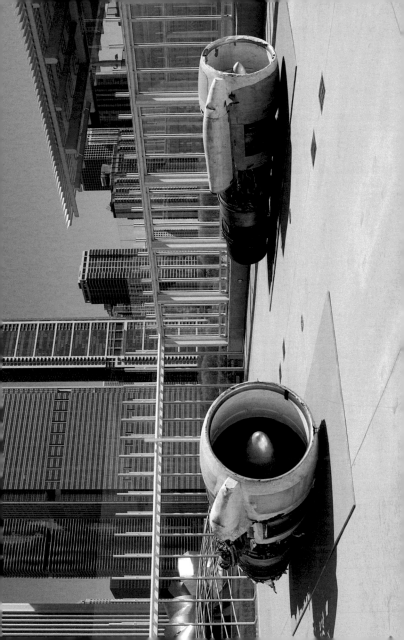

**The following text is an edited transcript of a
conversation with Roger Hiorns, which took place at
the Scottish National Gallery of Modern Art (SNGMA),
Edinburgh, on the occasion of installing *Untitled* as
part of exhibition *The Sculpture Show* (17 December
2011 — 24 June 2012). The artist was answering
questions posed by Caroline Douglas, Head of the
Arts Council Collection, and Simon Groom, Director of
SNGMA. A short film featuring the interview in full can
be seen online at www.artscouncilcollection.org.uk**

'I'm drawing attention to an object that might be thought
reprehensible in the future. I'm drawn to the idea that
art is a sort of 'National Park' of objects — that they're
separated from the world into this other set of rules,
other set of possibilities. Having come from the 'dust'
piece [*Untitled*, 2008] — a piece in which I atomised
a passenger jet aircraft — I was very much involved with
and interested in this kind of apparatus in particular:
this evolved piece of very sophisticated technology.

What we have here are two jet engines that did a
remarkable amount of mileage, acting as an instrument
of American surveillance in the late twentieth century.
After 9/11 it became very difficult to source old military
equipment of this kind. The United States Air Force
decided to take destruction of its objects in-house, rather
than employing secondary organisations for the purpose.
At the time of the commission [2010], one such company
were trying to sell these engines to the Israeli airforce,
but I managed to persuade them to sell them to us
instead. I think that they were intrigued by this slightly
unanticipated ending for the engines.

I'm interested to see if people even go anywhere near
them when they are installed. Do you actually want to
experience these things? They're not particularly inviting.
It's also interesting, at the Scottish National Gallery of
Modern Art (SNGMA), to see the engines in the context
of Charles Jencks' *Landform Ueda* (1999–2002). There's
a chaperoning of nature, in that work, into a structure
or form almost against itself; it's sculptural, in that sense,

and artificial. I had come from adapting nature in a particular way with *Seizure* [2008, in which a council-owned flat in London was filled with copper sulphate solution, which was then left to crystallise] and it's an idea I find attractive. It's interesting to put the two objects close together.

I've always been somebody who wanted to obscure or violate the concept of identity, and not calling yourself a sculptor is part of that. Not calling yourself anything, in fact, just trying to understand yourself in terms of the world. I've also always had, in parallel, a problematic relationship with the establishment of aesthetic and form in the present day. Perhaps we are post-ideological now, so how do aesthetic and form work when that's the situation? At the end of Modernism, does an object even need to have a form? All of these concerns, all of these problems, are inherently part of the issue of sculpture, and I sidestep them by saying "I work with objects".

I think there's an important role that sculpture can play in the future of materiality. What I'm probably describing, the role of the artist as I see it, is to identify objects, identify procedures — and ritualistic behavior too — and just isolate them, transpose them elsewhere and see what then begins. There are certain rules in the world, there's a certain choreography that applies to us as people in the world, and it's important to separate people from that. It's important to offer another way to relate to the world.'

EDINBURGH — INSTALLATION

Stills from a film made for the Arts Council
Collection, documenting the installation of
Roger Hiorns' *Untitled* (2010) at Scottish National
Gallery of Modern Art (SNGMA), Edinburgh, 2011.

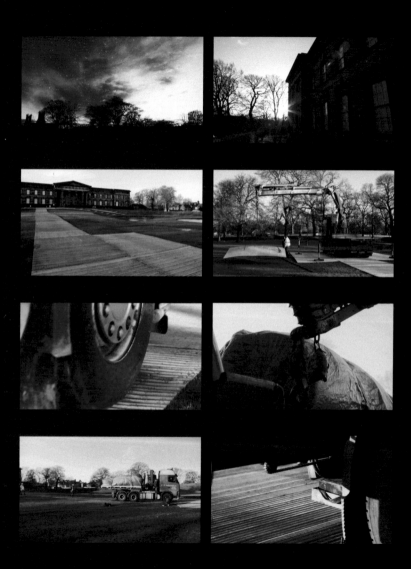

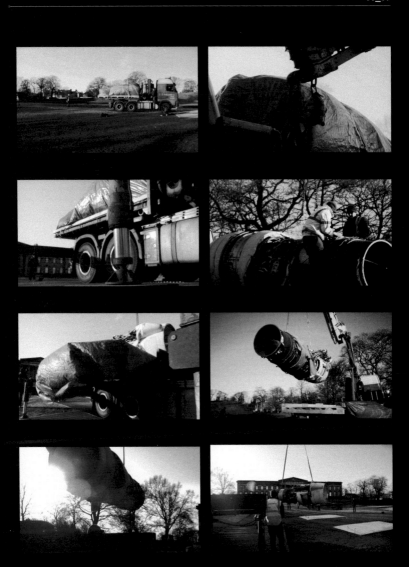

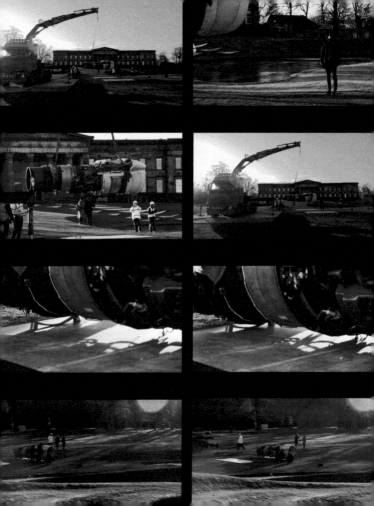

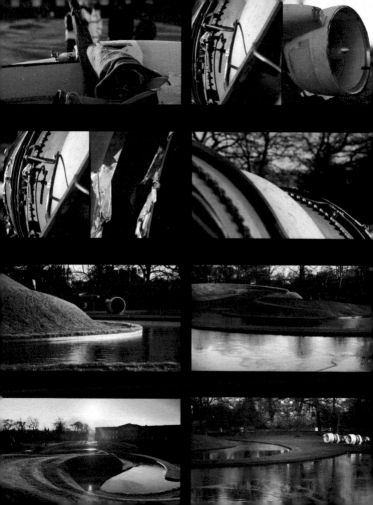

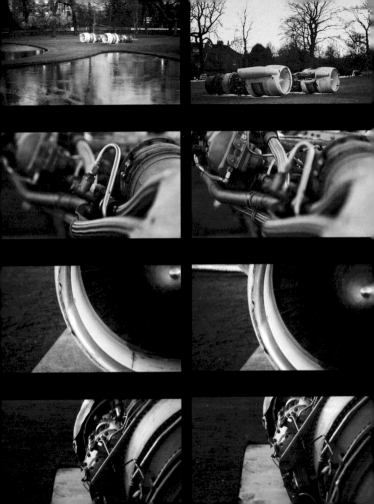

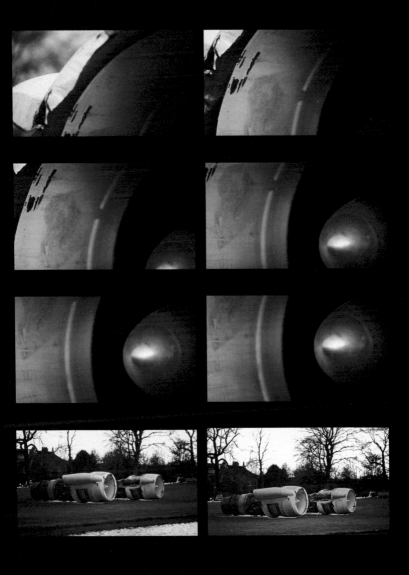

EDINBURGH

Untitled (2010) installed at SNGMA, Edinburgh, as part of exhibition *The Sculpture Show* (17 December 2011 – 24 June 2012). The work sits alongside Charles Jencks' *Landform Ueda* (1999–2002).

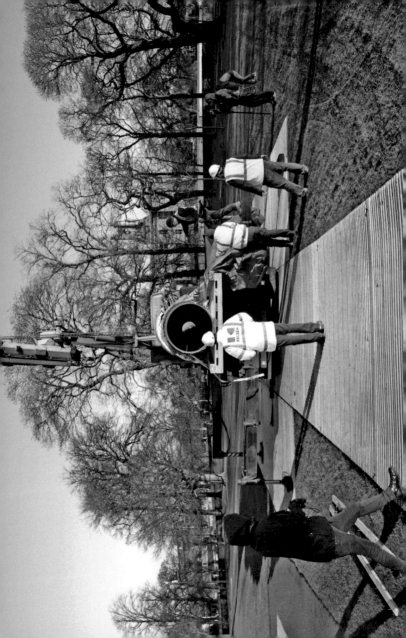

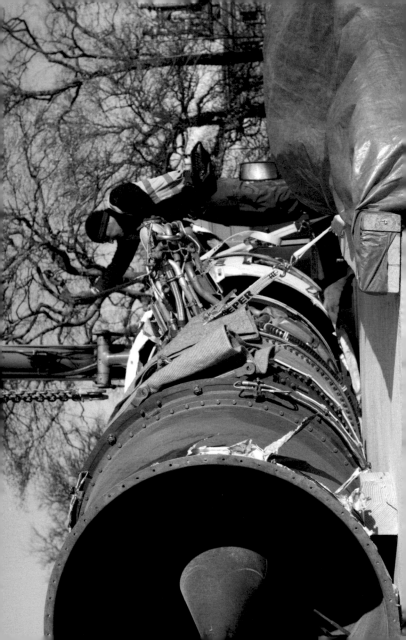

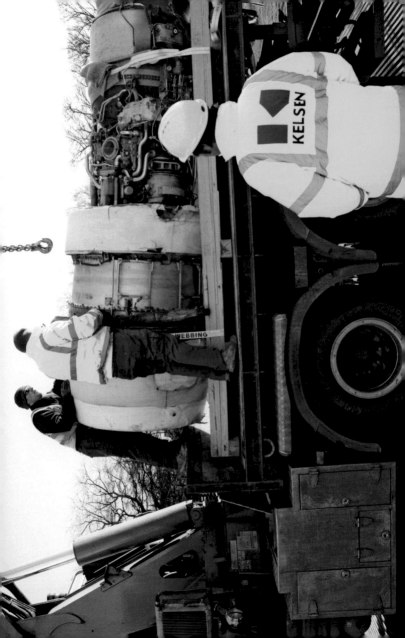

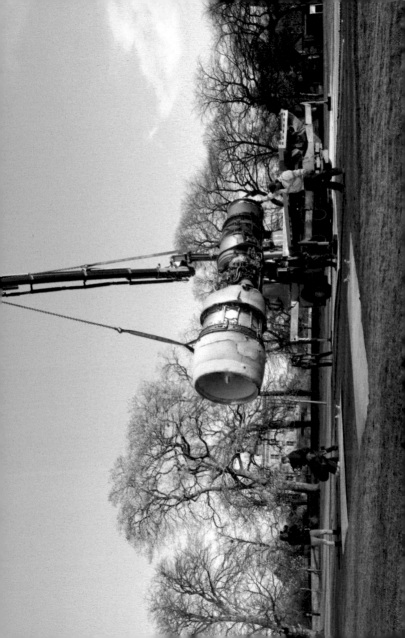

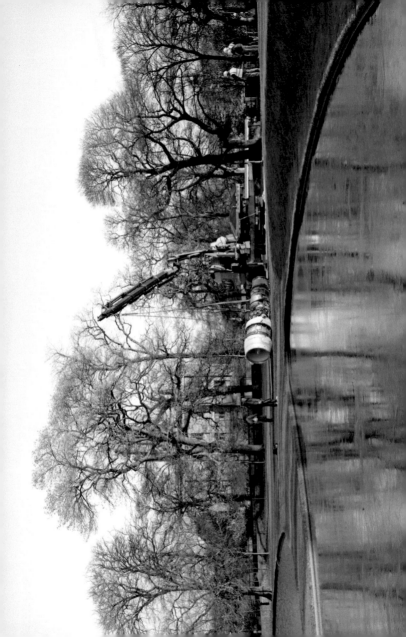

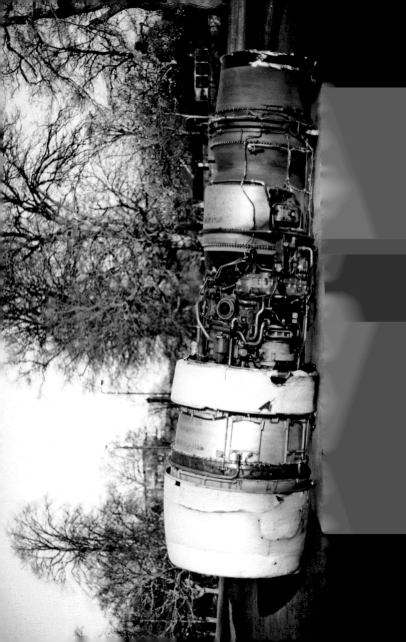

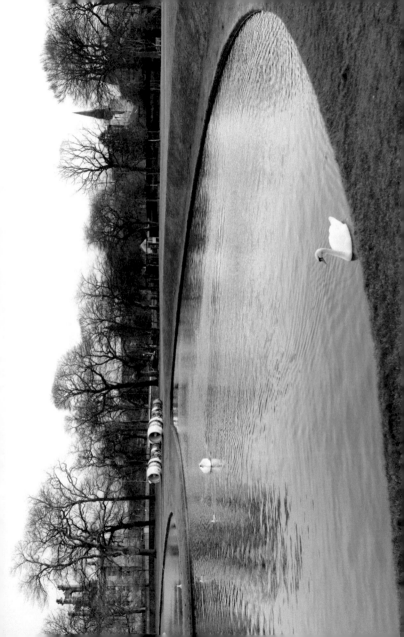

ROGER HIORNS
b.1975, Birmingham, UK.

1996
BA Fine Art, Goldsmiths College,
London

1991–93
Fine Art Foundation, Bournville
College, Birmingham

Selected Solo Exhibitions
2012
Marc Foxx, Los Angeles.
Untitled, class, part of *Wide Open
School*, Hayward Gallery, London.
Corvi-Mora, London.

2011
Annet Gelink Gallery, Amsterdam.

2010
Aspen Art Museum, Colorado.
Art Institute of Chicago.

2009
Turner Prize, Tate Britain, London.

2008
Seizure, Harper Road, an Artangel/
Jerwood Commission, London.

2007
The Church of Saint Paulinus,
Richmond, North Yorkshire.
Camden Arts Centre, London.

2006
Cubitt Gallery, London.
Milton Keynes Gallery.
Galerie Nathalie Obadia, Paris.

2005
Benign, Frieze Projects, London.

2003
UCLA Hammer Museum,
Los Angeles.
Art Now, Tate Britain, London.

Selected Group Exhibitions
2012
Common Ground, Public Art Fund,
City Hall Park, New York.
News From Nowhere, firstsite,
Colchester.
The Lot's Wife, Salisbury
Arts Centre.

2011
September 11, MoMA PS1,
New York.
*British Art Show 7: In the Days
of the Comet*, Hayward Gallery,
London; touring to Tramway,
Glasgow and Peninsula Arts,
Plymouth Arts Centre, Plymouth
City Museum and Art Gallery,
Royal William Yard and Plymouth
College of Art, Plymouth.
Dystopia, CAPC Museé d'art
Contemporain de Bordeaux.

2010
Art of Ideas: The Witching Hours,
Birmingham Museum and
Art Gallery, Waterhall Gallery.
*Gerhard Richter and the
disappearance of the image in
contemporary art*, Centro di
Cultura Contemporanea Strozzina,
Palazzo Strozzi, Florence.

2009
The Knight's Tour, De Hallen
Haarlem, The Netherlands.
The Quick and the Dead, Walker
Art Center, Minneapolis.

2008
A Life of Their Own, Lismore Castle
Arts, Co. Waterford.
Busan Biennale.
*Thyssen-Bornemisza Art
Contemporary as Aleph*,
Kunsthaus Graz.

2007
*If Everybody Had an Ocean: Brian
Wilson, an Art Exhibition*, Tate St Ives.
Destroy Athens, 1st Athens Biennale.
You Have Not Been Honest,
MADRE, Naples.

2006
*How to Improve the World:
60 Years of British Art*, Hayward
Gallery, London.

2005
British Art Show 6, BALTIC Centre
for Contemporary Art, Gateshead.
The Way We Work Now,
Camden Arts Centre, London.
Le Voyage Interieur, Paris-London,
Espace EDF Electra, Paris.

2004
The Fee of Angels, Man in the
Holocene, London.
A Secret History of Clay,
Tate Liverpool.
Particle Theory, Wexner Center
for the Arts, Columbus, OH.

Compiled by the artist

Where relevant, the year of the first English-language edition has been added in brackets to the end of each citation.

Hannah Arendt, *Crises of the Republic*, Harcourt Brace and Company, San Diego, 1972 (first published in English language edition, 1969).

Antonin Artaud, *The Theatre and Its Double*, tr. Victor Corti, OneWorld Classics Ltd, London, 2010 (1970).

Isaac Asimov, *Foundation*, first in the 'Foundation' trilogy, Collins, London, 1994 (1951).

Isaac Asimov, *Foundation & Empire*, second in the 'Foundation' trilogy, Collins, London, 1994 (1952).

Isaac Asimov, *Second Foundation*, third in the 'Foundation' trilogy, Collins, London, 1994 (1953).

James H. Austin, MD, *Zen-Brain Reflections: Reviewing Recent Developments in Meditation and States of Consciousness*, MIT Press, Cambridge, MA, 2010.

Alain Badiou, *Logics of Worlds*, tr. Alberto Toscano, Continuum, London, 2009.

Alfred Bester, *The Demolished Man*, 'SF Masterworks' series, Gollancz, London, 2004 (1953).

Augusto Boal, *Theatre of the Oppressed*, tr. Charles A. and Maria-Odilla Leal McBride and Emily Fryer, Pluto Press, London, 2008 (1979).

Louis-Ferdinand Céline, *Journey to the End of the Night*, tr. Ralph Manheim, New Directions, New York, 2006 (1983).

Existential Analysis, journal of The Society for Existential Analysis (SEA), Prof. Simon du Plock and Dr Greg Madison (eds).

William Golding, *The Inheritors*, Faber and Faber, London, 2011 (1955).

Martin Heidegger, *Being and Time*, ed. Dennis Schmidt, tr. Joan Stambaugh, State University of New York Press, Albany, NY, 2010 (1962).

Richard C. Keller, *Colonial Madness: Psychiatry in French North Africa*, University of Chicago Press, 2007.

Julia Kristeva, *Black Sun: Depression and Melancholia*, tr. Leon S. Rudiez, Columbia University Press, New York, 1992 (1989).

Bernard Malamud, *The Fixer*, Penguin Books Ltd, London, 1993 (1966).

Vladimir Nabokov, *Pale Fire*, Penguin Books Ltd, London, 2011 (1962).

John Onians, *Neuroarthistory: From Aristotle and Pliny to Baxandall and Zeki*, Yale University Press, New Haven, CT, 2008.

Rudolf Otto, *The Idea of the Holy: An Enquiry Into the Non-Relational Factor in the Idea of the Divine and its Relation to the Rational*, tr. John W. Harvey, Oxford University Press, 1976 (1923).

Eric Rhode, *Psychotic Metaphysics*, The Roland Harris Trust Library, Karnac Books, London, 1994.

Graham Robb, *Rimbaud*, Picador, London, 2000.

Marco Vidotto, *Alison and Peter Smithson: Work and Projects*, bi-lingual edition, Gustavo Gili, Barcelona, 1997.

ROGER HIORNS: UNTITLED (ACC25/2010)

Exhibition history to date:
Art Institute of Chicago
May 2010 – September 2010
Scottish National Gallery of Modern Art, Edinburgh
17 December 2011 – 24 June 2012
MIMA, Middlesbrough
September 2012 – September 2013

Published by Hayward Publishing
Southbank Centre
Belvedere Road
London, SE1 8XX, UK
www.southbankcentre.co.uk

Art Publisher: Nadine Monem
Staff Editor: Faye Robson
Sales Manager: Deborah Power
Catalogue designed by April
Colour management by Dexter Pre-Media
Printed in Belgium by DeckerSnoeck

A catalogue record for this book is available
from the British Library

ISBN: 978 1 85332 308 9

This catalogue is not intended to be used for
authentication or related purposes.
The Southbank Board Limited accepts no liability
for any errors or omissions that the catalogue
may inadvertently contain.

Distributed in North America,
Central America and South America by
D.A.P. / Distributed Art Publishers, Inc.,
155 Sixth Avenue, 2nd Floor,
New York, NY 10013
tel: +212 627 1999
fax: +212 627 9484
www.artbook.com

Distributed in the UK and Europe,
by Cornerhouse Publications
70 Oxford Street, Manchester M1 5NH
tel: +44 (0)161 200 1503
fax: +44 (0)161 200 1504
www.cornerhouse.org/books